EVERY
PERSON
ON
THE
PLANET

an only somewhat anxiety-filled
tale for the holidays

Bruce Eric Kaplan

SIMON & SCHUSTER
New York London Toronto Sydney

SIMON & SCHUSTER
Rockefeller Center
1230 Avenue of the Americas
New York, NY 10020

For information about special discounts for bulk purchases,
please contact Simon & Schuster Special Sales at
1-800-456-6798 or business@simonandschuster.com

Designed by Kim Llewellyn

Manufactured in the United States of America

1 3 5 7 9 10 8 6 4 2

Library of Congress Cataloging-in-Publication Data

Kaplan, Bruce Eric.
Every person on the planet / Bruce Eric Kaplan.
p. cm.
1. Brooklyn (New York, N.Y.)—Fiction. 2. International relations—Fiction.
3. Interpersonal relations—Fiction. 4. Parties—Fiction. I. Title.

PS3561.A5534E95 2005
813'.54—dc22 2005049796

ISBN-13: 978-0-7432-7470-8
ISBN-10: 0-7432-7470-9

This book is dedicated to every
person on the planet —
except for a few people.

So there was this couple
named Edmund and Rosemary
who lived with their cat Delia
on a quiet street in Brooklyn.

They led an
uneventful life
in which
they did
all
the same things
everyone
else
does
but
somehow

MONDAY

- cleaners
- drugstore
- bank
- call back
everybody

seem less painfully depressing
when you're the ones doing them.

Edmund and Rosemary
were not sociable people at all,
but one day they decided
to throw a party for the holidays.

"It would be nice to see everybody,"
they lied to each other.

They each got out a piece of paper
and began making a guest list.

First, there were family and friends.

Then all the people from work.

And of course everyone in the
neighborhood who, to tell the truth,

they didn't really feel they
needed to invite, but it
wasn't worth what they
would have to live through
if the neighbors saw there
was a party they hadn't
been invited to.

"Oh," Edmund said.

"What about the cousins?"

Rosemary hesitated.

Neither of them wanted to invite

the cousins because

there were so many.

But if you don't invite all the cousins,
that's all you ever hear about from
your parents and that's the last thing
Edmund and Rosemary needed.

So they invited each and every one
of them and sadly, their spouses who
they didn't care for in any way.

Particularly Edmund's cousin
Helen's husband Joe,
who was always
irate about something
no one ever cared about.

The list got longer,

and longer,

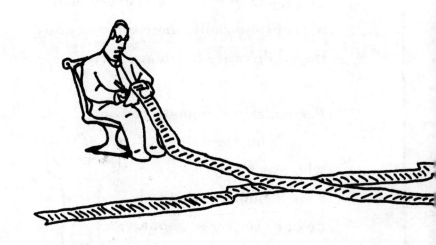

and longer.

Edmund and Rosemary tried to
eliminate people, but they couldn't.
All the people they didn't need to
invite had had them over to their
house in the past, so they *did* need
to invite them.

Rosemary resolved never to go
to anyone's house in the future
if this was the game everyone
was playing.

They both remembered more and
more people they had forgotten.

There was the man
whom Edmund desperately
hoped to someday
get a new job from.

And the woman whom
Rosemary was barely
acquaintances with but who
was friends with everyone
Rosemary was friends with
and thus whom she had
to see constantly.

Then there
was
that
glamorous
couple
they
had
just
met

whom they hardly knew at all but
thought they might like to be friends
with someday and if they didn't invite
them, that would never happen.

And then
there was
this
person

and
that
person

and
so on

and so on.

Still, Edmund and Rosemary thought
they might be forgetting people.

Until finally Edmund said,
"We should just invite every
person on the planet."

Rosemary laughed. Edmund said
he wasn't joking. She looked at him
and saw he wasn't.

"It's the only solution," he said.

Rosemary angrily wondered
if this was coming from
Edmund's pathological
need not to offend anyone.

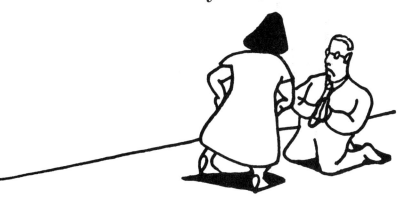

Edmund asked her not to analyze him.

But of course

that was not possible.

They had a small spat, using all the
communication techniques their
various therapists had taught them,

then got back to the
issue at hand.

Rosemary was resistant.

"If we invite everyone on the planet," she argued, "there'll be a lot of strangers and people we don't even like."

"That's what most of the list is already," Edmund replied.

"But," Rosemary wondered, "can we really fit six point three billion people?"

Edmund argued that at least half a billion wouldn't show.

"Still," Rosemary said.

As Edmund and Rosemary talked
about it, it really did seem that it
would be easier just to invite
everyone in the world.

So they did.

Edmund was in charge of
addressing the invitations
since he had neater handwriting.

Mr. and Mrs.

After the first dozen,
his hand started to cramp.

By the time he reached ninety
million, he was in pretty bad shape,

but he kept plugging away.

When he was finally finished,
he went somewhere private
and experienced all the
emotions that came up from
being so exhausted.

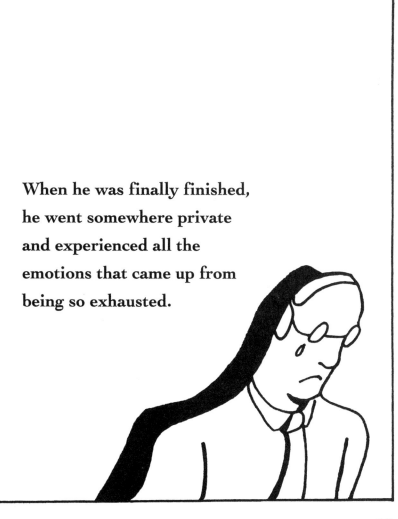

Rosemary was embarrassed for
Edmund and let him be

while she went to the post office.

Soon everyone in the world got
an invitation.

There was a lot of excitement
upon seeing the envelope and
wondering what it was,

then a small disappointment
over the actual invitation because
the reality is never as good as what
we hope it will be.

Still, everyone in the world
decided to attend.

Of course, only eight people actually RSVPed.

One night Edmund woke up
with a horrible thought.

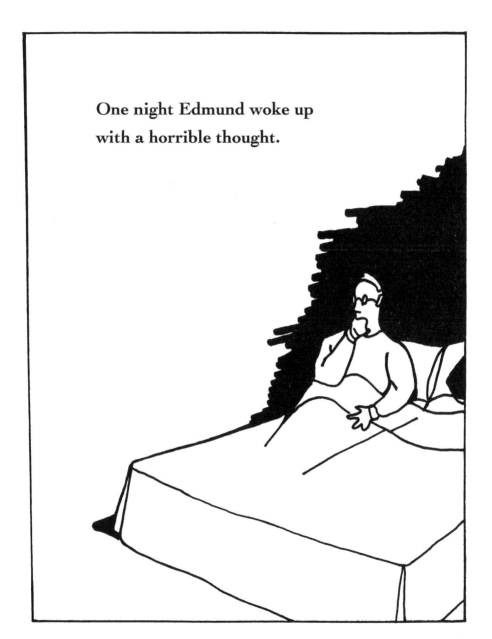

He nudged Rosemary and said, "We forgot a couple of Eastern European republics." They went out, bought more invitations, and mailed them. But it didn't do much good.

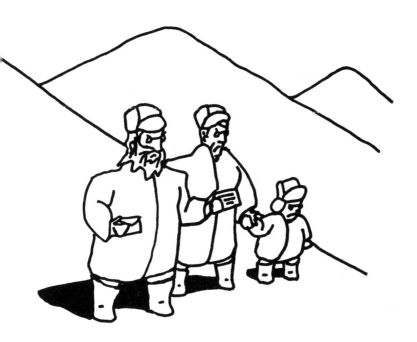

The people in the Eastern republics they
had forgotten were still offended, convinced
that they were just an afterthought.

For weeks, all the news shows

and papers did stories on
Edmund and Rosemary's party.

Then some
sports personality
did something bad

and the media moved on.

Airlines were overwhelmed
with reservations. Their
computers went
down even more
than usual, which
no one thought
was possible.

Edmund and Rosemary cleaned their apartment from top to bottom in preparation for having the whole world over. They threw out a lot of ugly things that were lying around for no good reason.

It's amazing how much crap you don't mind seeing every day until you realize someone else might see it and judge you.

They had to go out and
buy a punch bowl for the
party. Every one they
looked at was unappealing.

"Punch bowls are just
plain stupid," Edmund
decided.

But they ultimately found one
they almost didn't mind and got it.

Edmund was worried that they wouldn't have enough chairs. Rosemary felt people would be fine standing.

Edmund said, "They say they will be fine, but in truth people never are. About anything."

Rosemary couldn't argue with that.

Thankfully, all the cousins volunteered to bring extra chairs, which proved they were good for something.

Rosemary became

very focused on what

she was going to wear. She wanted something

that wasn't too f o r m a l but wasn't too

c a s u a l. It had to be f u n but also

e l e g a n t. It should be unique but

not look like she was

trying too hard. This was a lot

of pressure for one dress

to be under. She searched all over,

but nothing was quite right.

Days passed

and

slowly,

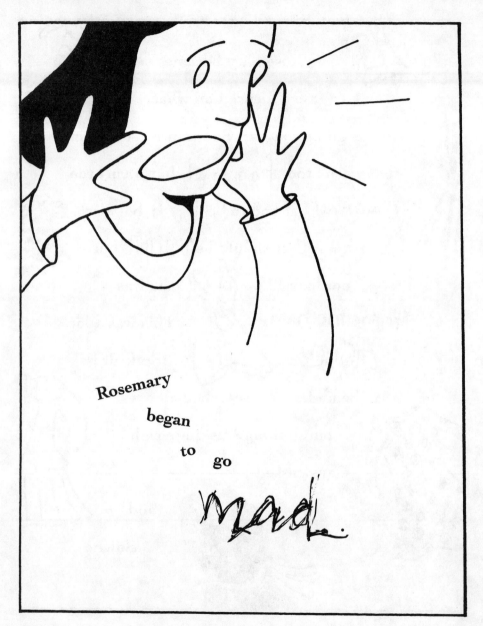

Rosemary

began

to go

mad.

Somehow, right before she
went over the brink, she
found something that she
wasn't entirely happy with,
but would do. So she spent
a lot more money than she
wanted to and was done
with the whole thing.

Then, of course, no
shoes would go with it.

Edmund didn't even begin to
think about what he
was going to wear until
fifteen minutes before
the party began.

He went into his closet,
threw on something,
and looked great.

It was yet another example
of how men have it easier
in every way, and
Rosemary tried
unsuccessfully
not to despise
him for it.

At eight o'clock on a wonderfully
crisp December night, Edmund and
Rosemary put the food and drinks out
and waited for their guests to arrive.

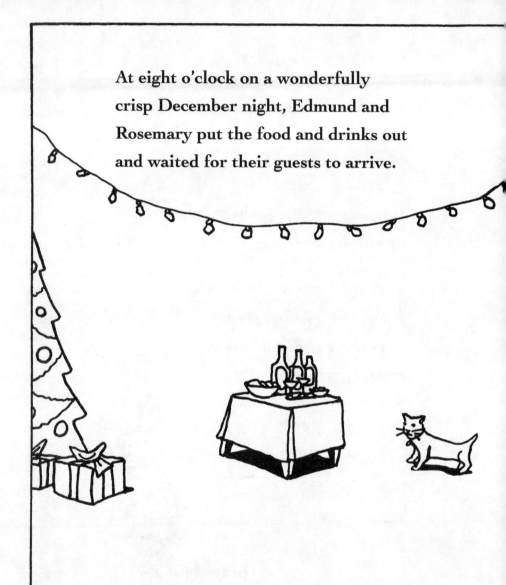

They sat down and a
wave of profound exhaustion
came over them.

"Why are we having everyone
in the world come here?" Rosemary asked.

Edmund was too tired to answer
and had no idea how they would get
through the evening.

They prayed for a second wind.

Just when Edmund and Rosemary
had begun to feel shunned by
the entire world,
people started
to
straggle
in.

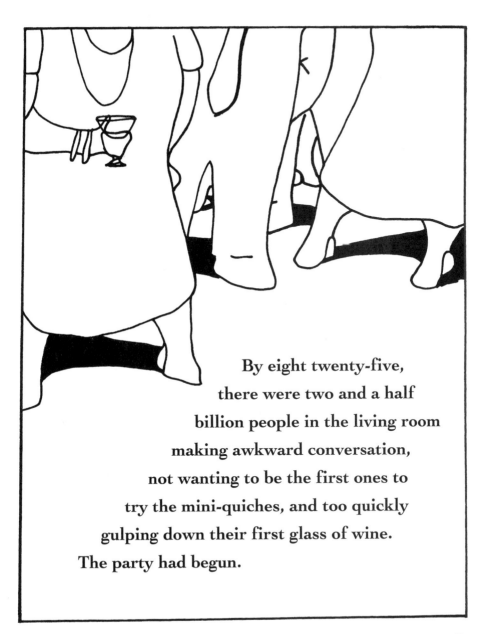

By eight twenty-five,
there were two and a half
billion people in the living room
making awkward conversation,
not wanting to be the first ones to
try the mini-quiches, and too quickly
gulping down their first glass of wine.
The party had begun.

Delia was angry about the whole thing and

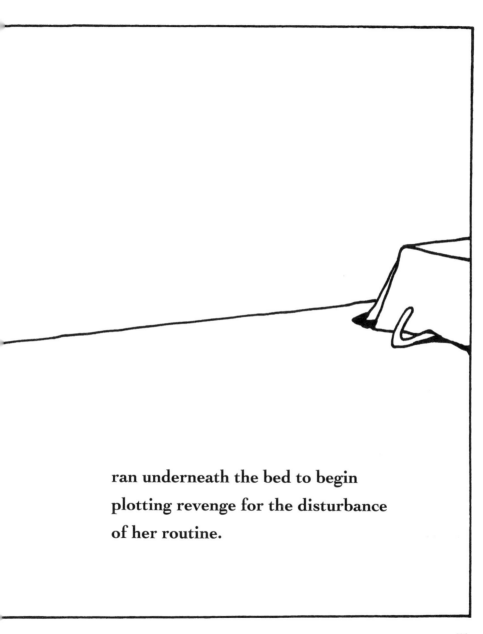

ran underneath the bed to begin
plotting revenge for the disturbance
of her routine.

Edmund and Rosemary greeted
one person after another and
struggled with the names of all
the people in the world.

Some were hard to pronounce
but, thankfully, everyone
else seemed to be named

Jennifer.

Worse than introducing themselves
to everyone, Edmund and Rosemary
had to then introduce the
people they had just met to
whoever next came up to them.

This preyed on Edmund's worst
fear—that when he was saying
someone's name was one thing,
it was really another and the person
was too polite to correct him.

He was in agony all night long.

The party was evenly divided

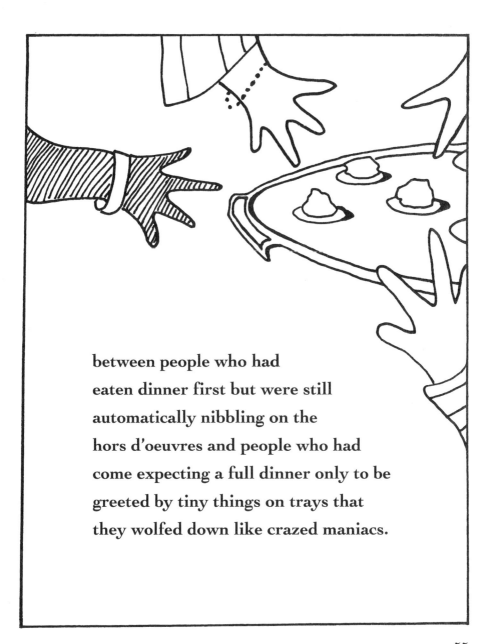

between people who had
eaten dinner first but were still
automatically nibbling on the
hors d'oeuvres and people who had
come expecting a full dinner only to be
greeted by tiny things on trays that
they wolfed down like crazed maniacs.

For the first hour,
Ella Fitzgerald was on the CD
player singing about chestnuts
roasting on an open fire and other
things like that. For more than five
hundred million people, this was
their first time hearing her.

Everyone around them was
shocked that they
didn't know who
Ella Fitzgerald
was and
made them
feel bad.

Then someone put on an eighties mix CD and people had annoying conversations about that.

Of course, a lot of people couldn't hear the music. And the person they were talking to would say, "I love this song," and they would reply, "Me too," not wanting anyone to know just how deaf they were getting.

Thirty-eight percent of the party felt their partner was acting too "on."

There was lots of flirting.

Millions upon millions of
people tried to interpret
playful sarcasm and with-
holding body language.

Actually, ninety-five million felt
they had met "the one."
Seven million would turn out to be right.

 Everyone remarked on how
attractive the Brazilians were.
Some bitchily said they didn't
really see it, but they did.

The line for the bathroom

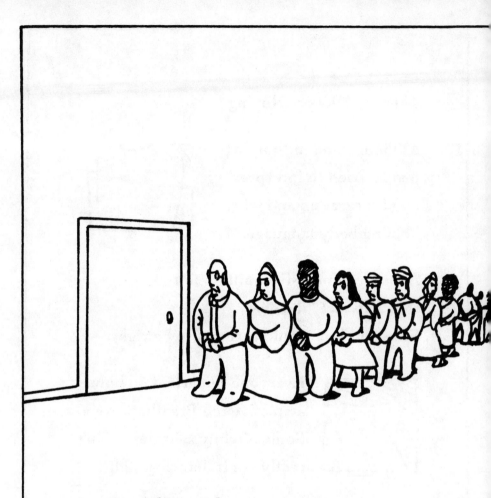

was nightmarish.

61

There were a lot of celebrities
there. In fact, every celebrity
was there.

Most of them behaved like the
silly disgusting animals they are.

The male celebrities were all gay.

The female celebrities

had all had

MASSIVE

amounts

of

plastic

surgery

and

all

talked

about how

they would

NEVER

have any

plastic

surgery.

Rosemary put her foot in her mouth
with several celebrities, then proceeded
to put her foot in her mouth many many
more times during the next hour.

Sometimes you just get on a roll
with these things.

"How cute," she said to one guest.
"You came dressed as Mrs. Santa Claus."

"No, I didn't," the
guest responded
huffily.

One in eight people at the party
cried inappropriately.

God, all the conversation was noisy.
Except for one miraculous half second
where everyone in the world was taking
a breath or about to change the topic
or just lost his or her train of thought.
There was complete total silence

and it was

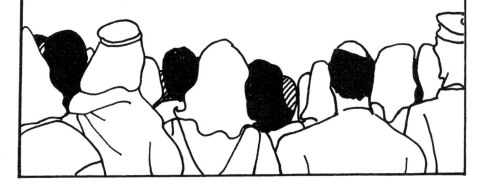

beautiful.

There were shy people who had
forced themselves to come,
determined to break out of their shell.

Not one of them did.

Instead, they just stood around aggressively, waiting for someone to break the ice with them. Some got angry when no one did, which of course is the annoying thing about shy people.

The other shy ones just got self-conscious and wandered over to the nearest bookshelf and pretended to be interested in whatever books Edmund and Rosemary had so no one would feel bad for them.

Everyone still felt bad for them.

Typically, the Americans used up
most of the resources at the party.

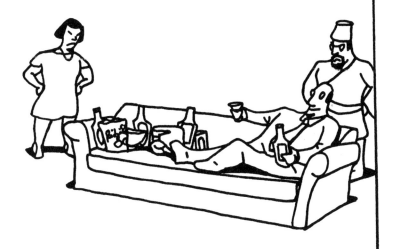

There were some no-shows.
A lot of bad directions

had been given.

More to the point, good directions
had been given and ignored by
people who thought they knew
better. Without fail, the people
who think they are the most right
are always the most wrong.

The party was going well, yet
Rosemary hit a low and became
convinced that everyone in
the world was having a bad time
and somehow resented her.

She quickly went to the bedroom
to hide from what she mistakenly
perceived to be stares of hatred
and disgust.

Edmund was in a conversation with a woman from Iceland, who was feigning interest in a short story Edmund had just read.

Actually, every single person at the party feigned interest in something at some point during the night. All but a few got extremely exhausted by the feigning, because really, it is tiring and it would be so nice if one didn't have to feign so much, wouldn't it?

After a while, Edmund began looking for
Rosemary. He found her in the bedroom,
gazing out the window. It had started to
lightly snow. He asked her what was
wrong and she told him. Just saying
it out loud dissipated her feelings.
He held her and she felt better.
Delia stayed under the bed the
whole time, filled with
disgust for their
kind.

Edmund coaxed Rosemary back to the
party where she resumed her duties
of hostessing the world. She put out
more holiday cookies.

Some guests thought
they were too dry

while all the other
ones thought they
weren't dry enough.

Also, Rosemary had to constantly
collect those annoying little
overpriced cocktail napkins off any
available surface and of course

she needed to boil water and keep
putting out clean towels because

millions of babies were born.

And millions of people died.

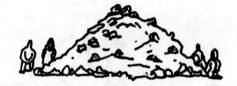

**Which involved even
more cleanup.**

There were a lot

 of

 very old,

 very sick,

 and

 very crazy

 people,

and for once,

for some strange reason,

no one neglected them.

At eleven-thirty, everyone looked around
and noticed the entire world
was in the kitchen

and no one was in the rest of
the apartment.

A billion people ran into their exes,
which was awkward for them,

and everyone else. It was
a real argument for staying
in touch with your exes,

but not one that
was convincing
enough to make
any significant
amount of the
population do it
in the future.

God, the politicians
were clichés of themselves.
They were so grabby with
the younger people.

Same thing with the aging
professional musicians.

**Also, there were a couple
of crashers.**

A quarter of the world's population had a little too much to drink.

A significantly higher percentage had way too much.

Rosemary was in that category.

She staggered around, telling
everyone what she really thought,
which, as we all know,

is the last thing you should
ever do.

Then she came across Corinne
Madison, whom she knew from
elementary school. Corinne had
always been one of those quietly
mean girls.

Corinne made some condescending
remarks about Rosemary's home
and Rosemary lost all control,
telling Corinne what a terrible
person she was in every way.

It wasn't very evolved of Rosemary,
but it did feel good.

A crowd gathered around them.
At one point, Rosemary realized that

the whole world was on her side.
It was the high point
of her entire life.

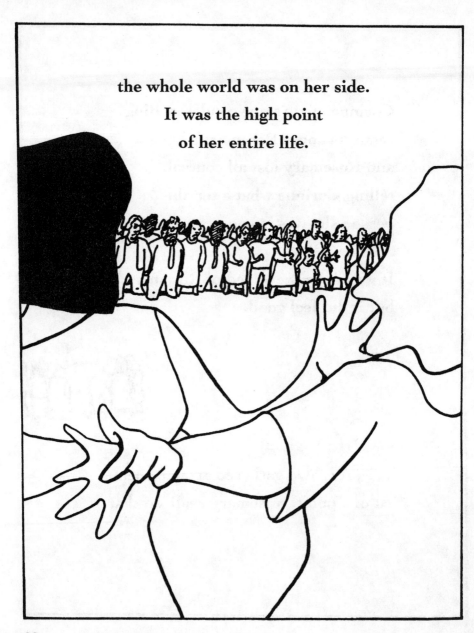

Edmund missed the whole thing.
He had wandered up to the roof,
suddenly in the middle of an
intense spiritual crisis. He
wasn't sure what had brought
it on. Perhaps it was because
he had now met every
single person in the
world yet still
felt essentially
alone.

Some Himalayan sheep herders
stood smoking near an antenna.

Edmund immediately went over and
desperately bummed a cigarette
from them, even though he didn't
normally smoke.

Despite a language barrier, soon
they were all laughing, having a
good time, and somehow exchanging
intimacies.

Edmund's existential despair was
relieved, all because he had
extended himself with some
strangers.

Edmund had an epiphany.
He realized he had the power to
feel connected to anyone, but it
was all up to him. He determined
to make this his life's work,
starting tomorrow. Of course when
he woke up the next morning, he
forgot all about it. He continued

 to have spiritual
crises periodically
as he always had,
which was one of the things about
him that Rosemary had just
learned to live with.

When Edmund came back downstairs,
he noticed the party was thinning out.
Only eight hundred million people
were left. The Australians seemed
like they were really determined to
close the place.

Edmund and Rosemary were
overwhelmed by having to tell
every person on the planet
how good it was to see them.

They were relieved that some people just slipped out when they thought Edmund and Rosemary weren't looking

and they wondered why more people couldn't be less polite.

A lot of people

took the

wrong coat

home,

not always accidentally.

Suddenly, one or two of the most popular people left, and took everyone else with them. And in the space of a few seconds, the party was over. Well, a few hundred terrible people were still there, but Edmund and Rosemary blew out the candles, turned on all the lights, and started cleaning up.

They got the hint.

And finally, Edmund and Rosemary
were alone once again.

Delia came out from under the
bed and sniffed around.

She was disgusted with what
kind of shape the world had
left the bathroom in.

Edmund and Rosemary were
going to put away the leftover food but they
realized not a single thing was left uneaten,
which made sense because an enormous part
of the population had been starving.

Rosemary said, "I told you we
should have bought more."

Then they threw out the trash

and got ready for bed.

They relived the stranger
moments of the party as they
washed their faces. They laughed
and appreciated each other. Both of
them were the type who liked
talking about a party much better
than actually experiencing it, and
this is part of what had drawn them
to one another in the first place.

They got into bed, which had never felt so good. Edmund said he was glad they had thrown the party. Rosemary agreed for the most part.

"I could have done without a couple of continents," she said. "But it was fun."

"The world is nice," Edmund said
with a great yawn.

"Much better than I would have
thought," Rosemary murmured

and they went

to sleep.

BRUCE ERIC KAPLAN
draws cartoons for *The New Yorker,*
among other publications. Much of his work
has been collected in *No One You Know* and
This Is a Bad Time. He has also written and
illustrated the cult classic *The Cat That Changed
My Life.* He lives in Los Angeles where he has
written for such television shows as
Seinfeld and *Six Feet Under.*